WAR PHOTOGRAPHERS

Published by IWM, Lambeth Road, London SE1 6HZ
iwm.org.uk

ISBN 978-1-912423-66-8

A catalogue record for this book is available from the British Library.
Printed and bound by Gomer Press Limited
Colour reproduction by DL Imaging

Every effort has been made to contact all copyright holders.
The publishers will be glad to make good in future editions
any error or omissions brought to their attention.

Front cover: Paul RG Haley, photographed on Goat Ridge with his cameras shortly
after the ceasefire, photographed by official photographer Sergeant Ron Hudson.
FKD 312 © Crown

Back cover: The grave of Betty Stevenson of the Young Men's Christian
Association (YMCA) tended by a member of the QMAAC.

www.carbonbalancedprint.com
CBP2275

WAR PHOTOGRAPHERS

Helen Mavin

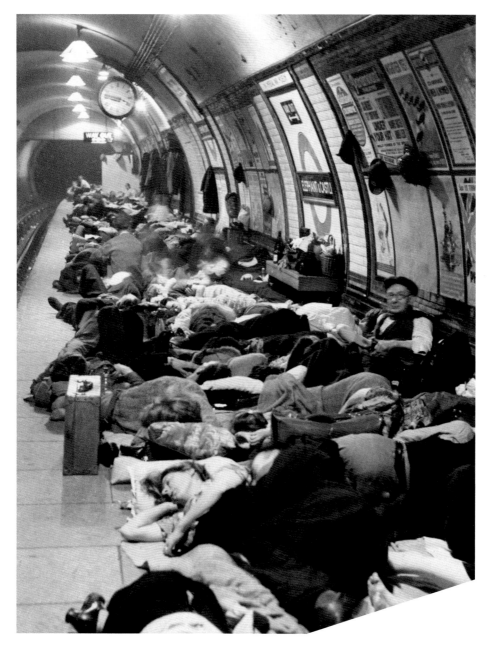

People sleeping on the crowded platform of Elephant & Castle Underground Station, London, November 1940.

The IWM Photograph Archive covers over 100 years of war and conflict. It holds approximately 11 million photographs taken by a range of individuals, both amateur and professional, who were personally motivated or employed to do so.

Photography has been, and continues to be, used in war for a variety of roles, from aerial reconnaissance, medical work to propaganda.

Offering a visual insight into war and conflict, photographs have the power to document and reveal, but also to hide or distort events, depending on the motivations of the photographer and how images are circulated.

The five photographers featured in this book, selected from IWM's collection, represent professional war photography and reveal how photographs have shaped the way we visually understand the events of the twentieth century.

Mary Olive Edis (1876–1955)

Pioneering professional photographer Olive Edis was based in Norfolk, with studios in both Surrey and London.

In October 1918, Agnes Conway, the Honorary Secretary of the Women's Work Sub Committee of the newly established National War Museum (later Imperial War Museums), invited Edis to photograph women's services in France and Belgium. She became the first IWM commissioned female photographer.

Originally planned for November 1918, the work went ahead in March 1919, shortly after the end of the First World War. Lady Norman, Chair of the Women's Work Sub Committee, had

concerns that the opportunity to create a record of women's roles was being lost, as, by this time, women were travelling home. Dame Maud McCarthy, the Matron-in-Chief in France, also worried that photographs taken in 1919 would present a 'totally different' view in contrast to the work undertaken before the Armistice.

Edis travelled with three cameras and dozens of glass plates. Reflecting on her experience in a letter to Lady Norman after her assignment Edis said:

> 'I am very glad to be able to do this little bit of work for the museum. ... and only hope that the results will be satisfactory. I know that I have your sympathetic understanding of the extraordinary difficulties under which I have sometimes to work out there.'

She created a lasting record of women's war work during the First World War.

Vera Elkan (1908–2008)

South African-born Vera Elkan spent much of her youth in Europe and trained in photography in Berlin. After returning to South Africa to set up her own studio, she relocated to London at the age of just 25.

IWM holds photographs taken by Elkan on an assignment to create a film about the Spanish Civil War (1936–1939) — a conflict between the Popular Front government of the Spanish Republic (an alliance of republicans, socialists and communists) and Nationalists, led by General Francisco Franco, who were trying to overthrow the Republic. The film was intended to be shown in Britain to promote the International Brigades and raise awareness and funds for the Republican cause.

During her time in Spain, between December 1936 and January 1937, Elkan spent time in Madrid, and unofficially attached herself to the Canadian Blood Transfusion Unit run by Dr Norman Bethune. She pictured the working conditions and procedures undertaken and visited the frontlines, including the capital's University City while it was under bombardment. She photographed the International Brigades, which were military units made up of volunteers willing to fight in support of the Popular Front government.

Elkan recalled that it was easier to view the difficult scenes around her through a camera as everything was 'so much smaller and so much less personal'.

Herman Wilhelm 'Bill' Brandt (1904–1983)

Bill Brandt was born in Germany and discovered photography in Vienna. He further developed his style in Paris, influenced by avant-garde photographers, such as Man Ray and Brassaï, before moving to London in 1934.

During the 1930s, Brandt worked as a freelance photographer of British society, juxtaposing photographs of large wealthy families against working class homes, and undertook commissions for popular illustrated magazines.

In November 1940, Brandt visited London's air raid shelters on behalf of the Ministry of Information – the British Government's department for propaganda. Using his Automatic Rolliflex camera, he played with light sources and manipulated images in his darkroom to create intense photographs of Londoners sheltering underground from German bombing raids.

Published in *Lilliput* magazine in December 1942, Brandt's photographs appeared alongside sketches by the artist Henry Moore. They were also exhibited in the Museum of Modern Art

in New York, and sent to President Roosevelt to highlight the difficult conditions in London.

Brandt's works are an intimate insight into the hardship of life under aerial bombardment.

James 'Jimmy' Mapham (1909–1968)

Sergeant Jimmy Mapham, a photographer for the *Leicester Mercury* before the Second World War, became an official photographer in the Army Film and Photographic Unit (AFPU).

The AFPU was set up in 1941 to compete with the German propaganda effort and meet the demand for photographs in the UK and abroad. A training centre was established at Pinewood Film Studios, Buckinghamshire. Many of the men recruited to the new unit to document the war were from the film and photography industry.

Mapham photographed the war in North Africa, England and North-West Europe. He was one of 13 APFU cameramen to land with troops in Normandy on D-Day and is recognised as having produced some of the most iconic photographs of the British landings.

The men of the AFPU risked, and in some cases lost, their lives to document the Second World War. Their contributions indelibly shaped how the war was seen and remembered. Their photography was used not only in the wartime propaganda effort but also as evidence, most notably, of the Holocaust.

Paul RG Haley (1950–present)

Yorkshire-born Paul Haley was a civilian photographer working for the Ministry of Defence (MOD) magazine *Soldier* when the Falklands Conflict started in 1982. The conflict was a short undeclared war between Argentina and Britain over the

sovereignty of the Falkland Islands, South Georgia and the South Sandwich Islands.

Working as a photographer since the age of 15, Haley had worked for the MOD at the Royal School of Artillery, Larkhill, before moving to *Soldier*. During his 13 years at the magazine, Haley covered a range of British Army activities from training in Canada and Kenya to active tours in Northern Ireland and Cyprus.

Initially told that no one from *Soldier* would be travelling to the Falkland Islands to cover the conflict, Haley was given fewer than 24 hours' notice of his planned departure on the refitted cruise liner *Queen Elizabeth 2* (*QE2*).

During the voyage, Haley documented the preparations onboard *QE2*. He landed in San Carlos with the 5th Infantry Brigade after the Battle of Goose Green and covered activities around Darwin, Fitzroy, Goat Ridge/Tumbledown and Port Stanley.

Reflecting on the challenging conditions he encountered, Haley said, 'photography was the least of my worries... trying to keep warm and dry and keep my cameras dry was the challenge'.

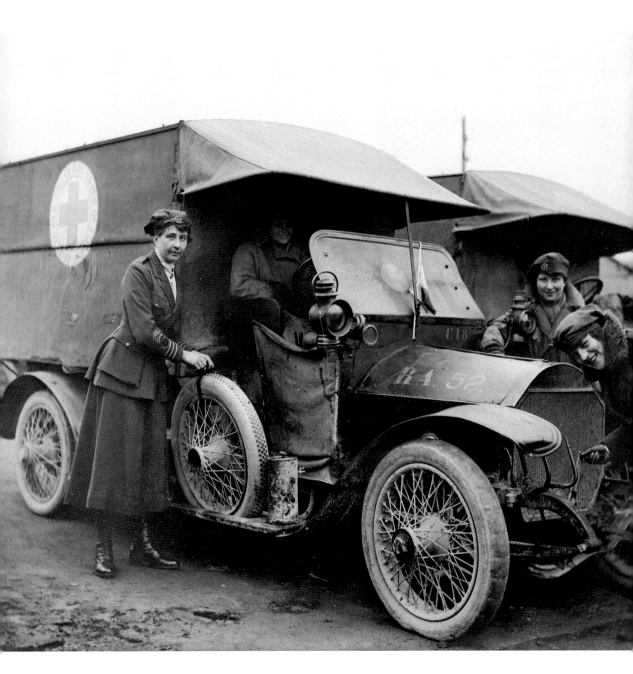

Miss Franklin and three other First Aid Nursing Yeomanry (FANY) members preparing their ambulance, Calais, France, 3 March 1919. Established in 1907, the FANY's initial role in the war was to drive ambulances for the Belgian and the French forces. They were not officially recognised by the British War Office until 1916, after which they undertook additional roles including transport and medical care.

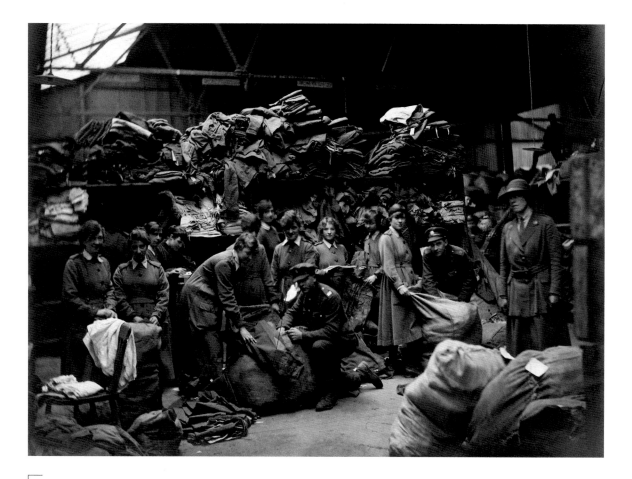

Established in 1917 to undertake auxiliary
work and free up men for war service, the
women of the Women's Army Auxiliary
Corps (WAAC), later the Queen Mary's Army
Auxiliary Corps (QMAAC), often completed
laborious work in locations such as this
clothing store of a British Army ordnance
depot in Vendroux, France, 1919.

Miss Kirk and Miss Loy serving tea to soldiers in the Church Army station hut in Saint-Omer, France, c.7 March 1919. The Church Army funded recreation huts, tents and centres to provide 'cheer and comfort' to troops at home and on fighting fronts.

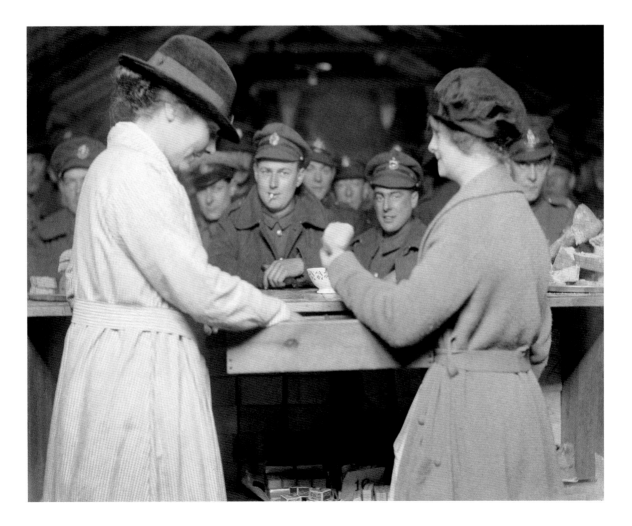

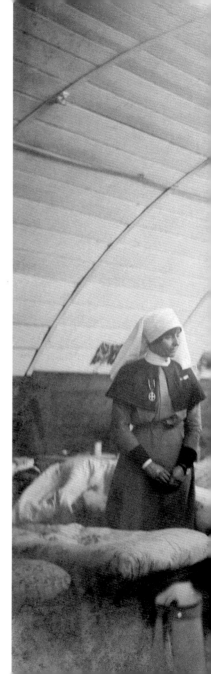

Doctors and nurses tending to patients in the German ward of No. 4 Stationary Hospital in Longuenesse, France, 7 March 1919. Over 100,000 British women volunteered as nursing staff during the war.

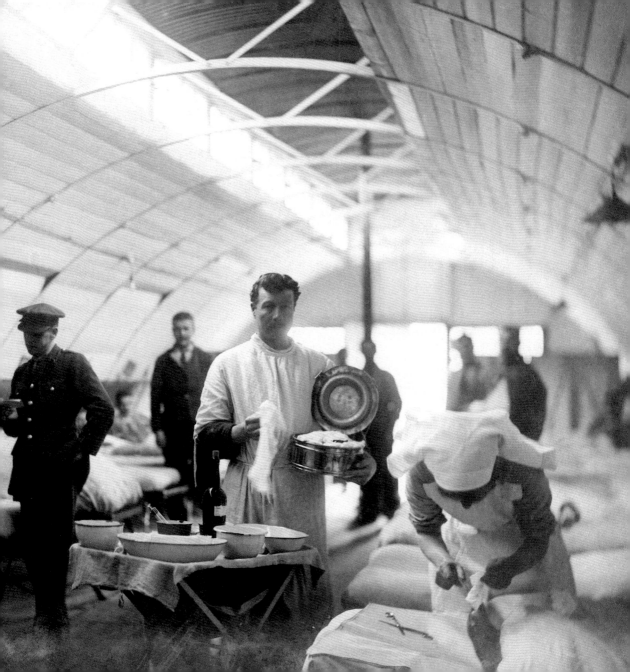

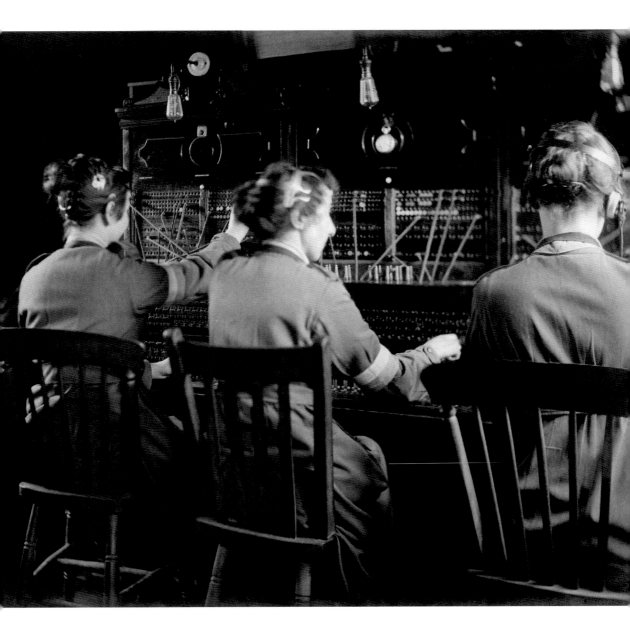

Women of the QMAAC operating a
telephone exchange at No. 4 Rest Camp,
Henriville, France, 8 March 1919.

Colonel Fullerton and nurses operating on a patient's leg at No. 32 Stationary Hospital, Wimereux, France, 9 March 1919. Originally the Australian Voluntary Hospital, it was absorbed by the British Army in June 1916. During this visit, Edis sustained damage to her camera, when an orderly let it drop onto the hospital's polished floor.

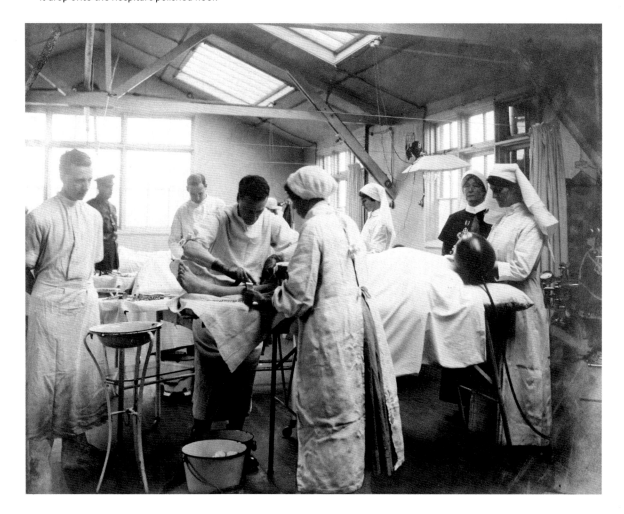

The grave of Betty Stevenson of the Young Men's Christian Association (YMCA) tended by a member of the QMAAC at a graveyard in Étaples, France, 10 March 1919. Edis described the cemetery as a 'perfect forest of little wooden crosses' and specifically sought out Stevenson's grave to photograph. Stevenson was killed by a bomb during a German air raid on 30 May 1918, aged 21.

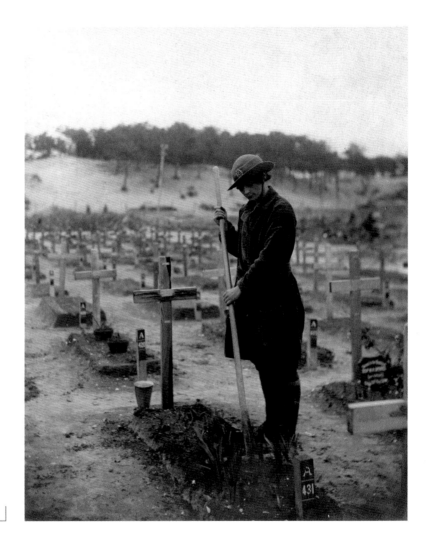

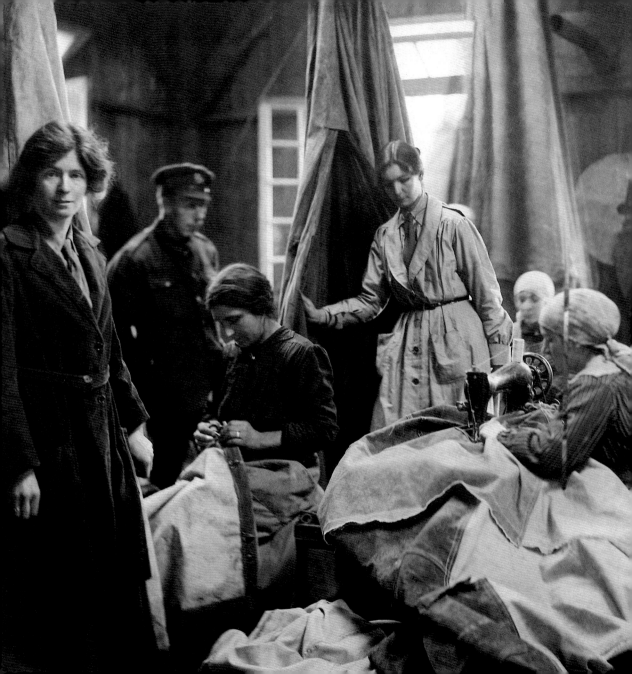

French civilian women repairing tents using a treadle sewing machine and hand stitching under the supervision of Miss Philpots and Miss Leacock, QMAAC, No. 8 Ordnance Depot, Abbeville, France, 11 March 1919. This moment was described by Edis in her diary as 'quite the prettiest scene of the kind I had had a chance of'.

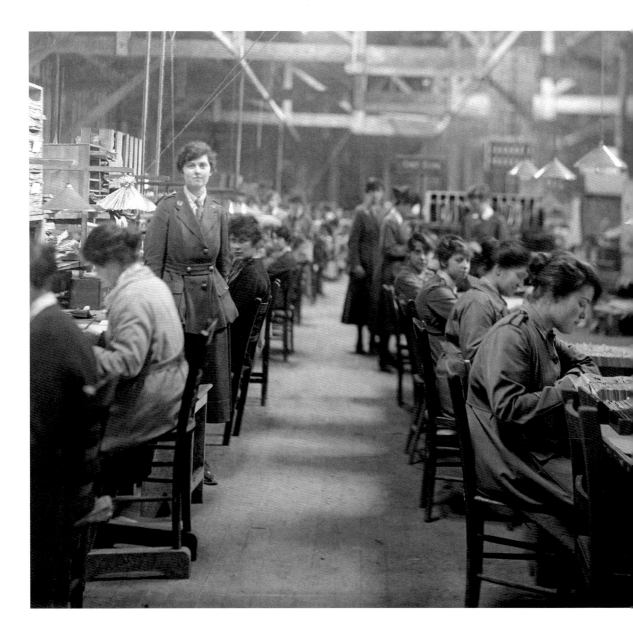

The Technical Administrator, Miss Nicholls, and women of the QMAAC working in the Stores Office at the 61st Advanced Motor Transport Section in Abbeville, France, 11 March 1919.

A member of the QMAAC acetylene welding at a Royal Air Force (RAF) engine repair shop in Pont-de-l'Arche, France, 14 March 1919. This type of gas welding was used to weld thin sections of metal.

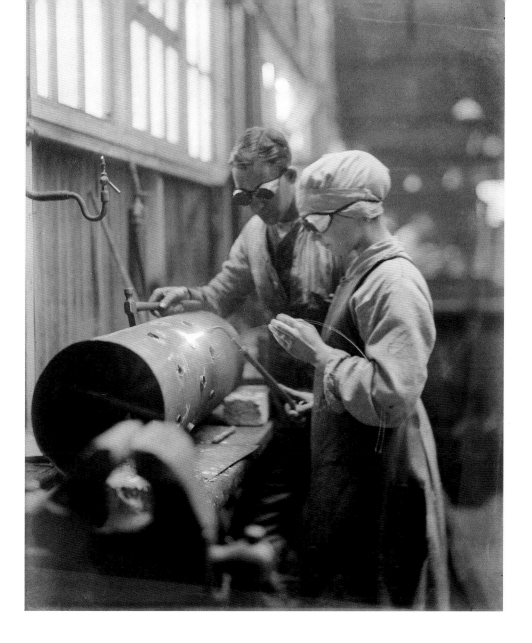

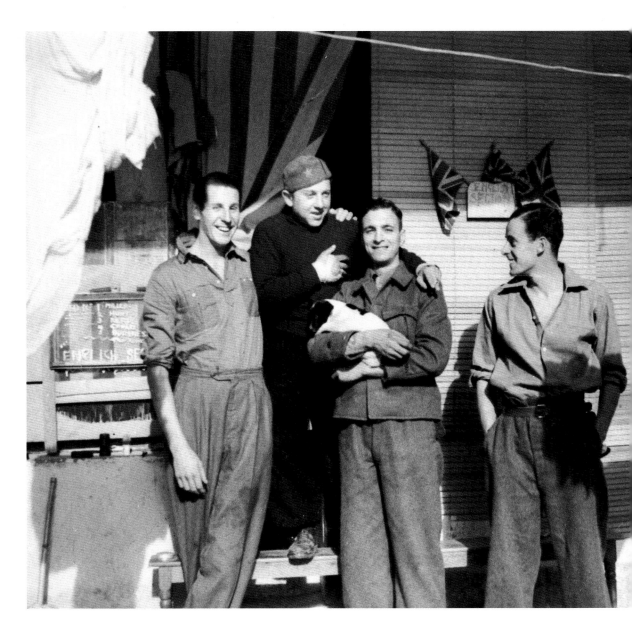

Four British members of the International Brigades stand in front of their camp. Behind them, a handwritten sign which says 'ENGLISH SECTION' is draped with three Union flags. The British Battalion was multi-national, comprising of British and Dominion volunteers.

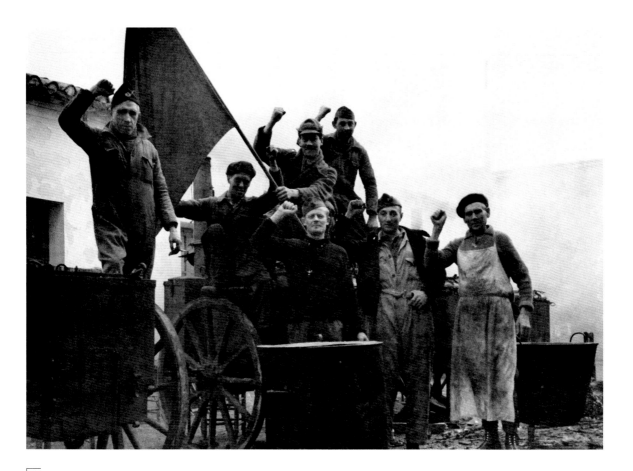

Members of the International Brigades at the British cookhouse in Albacete, Castilla-La Mancha, Spain, raise their fists in the Communist salute. Albacete was the location of the Brigades' headquarters. Vera Elkan did not consider herself a communist, but believed she was united with others through their shared anti-fascist views. Prior to her trip to Spain, Elkan had been working with refugees from Nazi Germany in London.

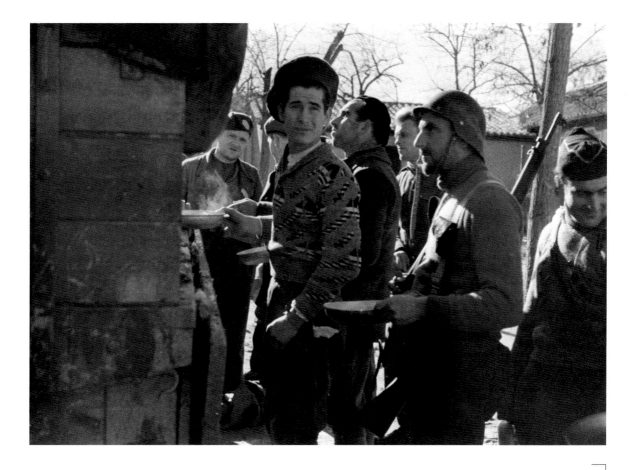

Soldiers of the International Brigades gather alongside the food truck to receive their meal of potato stew. The variation of their uniforms and clothing demonstrates the international make-up of the Brigades.

Soldiers of the International Brigades congregate to watch a gas mask demonstration. Asphyxiating gas was used for the first time during the First World War, but, by the start of the Spanish Civil War, using chemical and biological weapons in warfare had been outlawed by the 1925 Geneva Protocol.

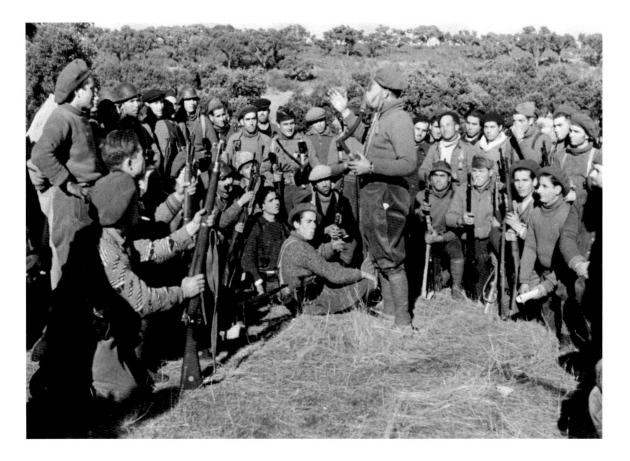

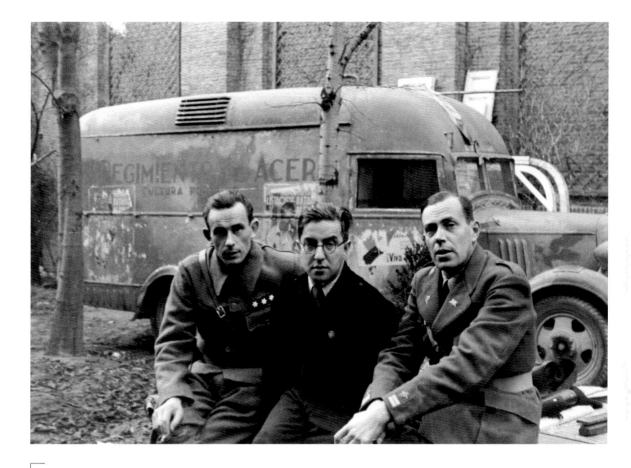

German journalist Hans Kahle (right) and a fellow senior commander of the Thälmann Battalion (left) pose with an unidentified Spanish soldier (centre). The battalion was a principally German unit named after the leader of the German Communist Party, Ernst Thälmann, who was imprisoned under the Nazi regime and later murdered in Buchenwald concentration camp.

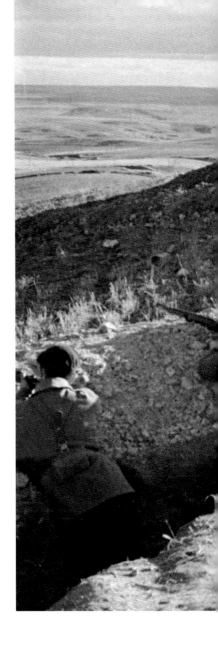

A group of Italian soldiers on the Guadarrama
Front stand along a trench in a heavily ploughed
field, with their rifles at the ready. Elkan's experience
at the fronts she visited was varied; she noted the
hospitality of everyone she met and recalled how
'thrilled [they were] to see a female'. However, the
danger was ever present, and Elkan was shot at
in a trench when her camera lens drew attention
as it had not been blacked out.

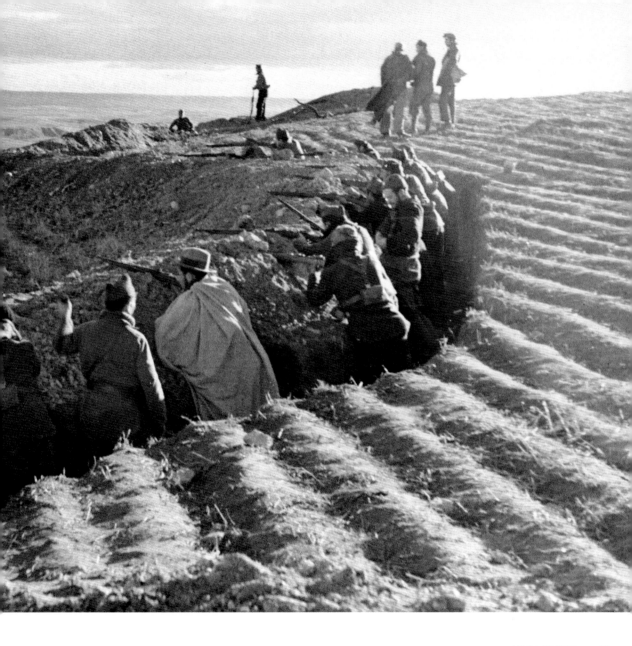

A Spanish doctor performs a direct
blood transfusion in Madrid Hospital.
Elkan frequently photographed blood
transfusion and medical work.
While difficult procedures to watch
she found that viewing them through
her camera meant they did not
look 'nearly so horrible'.

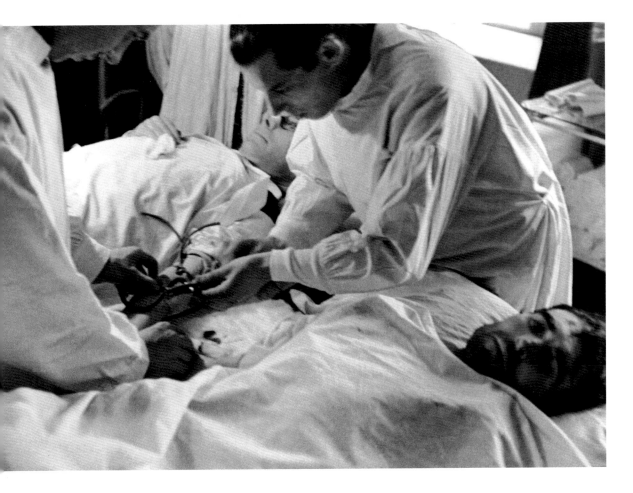

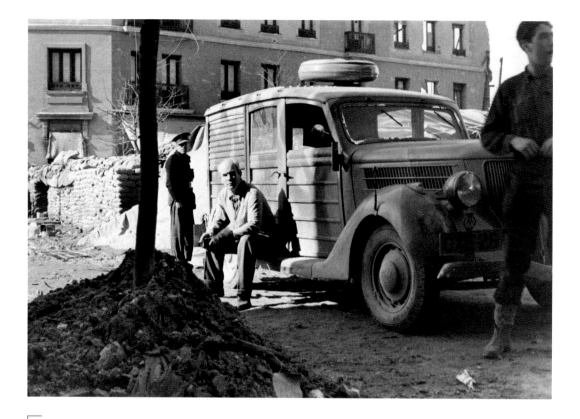

Canadian surgeon, Dr Norman Bethune,
sitting on the running board of an
ambulance of the 'Servicio Canadiense de
Transfusión de Sangre' – Canadian blood
transfusion service. Bethune was a pioneer
of mobile blood transfusions, transporting
much-needed blood supplies to the
fighting fronts.

A casualty on a stretcher is rushed through the debris-littered streets of Madrid. Behind the stretcher bearers, a huge stack of sandbags and a pock-marked building are visible. This photograph is blurred due to the fast movement of the subjects.

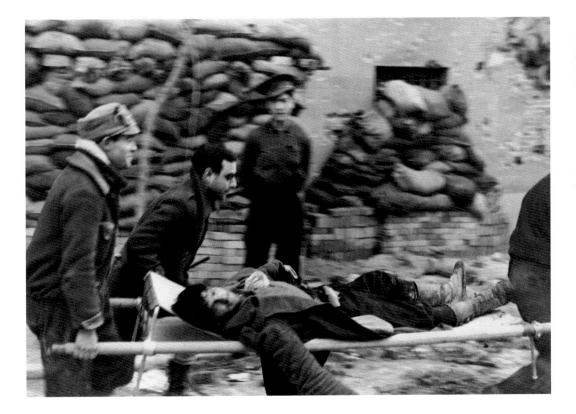

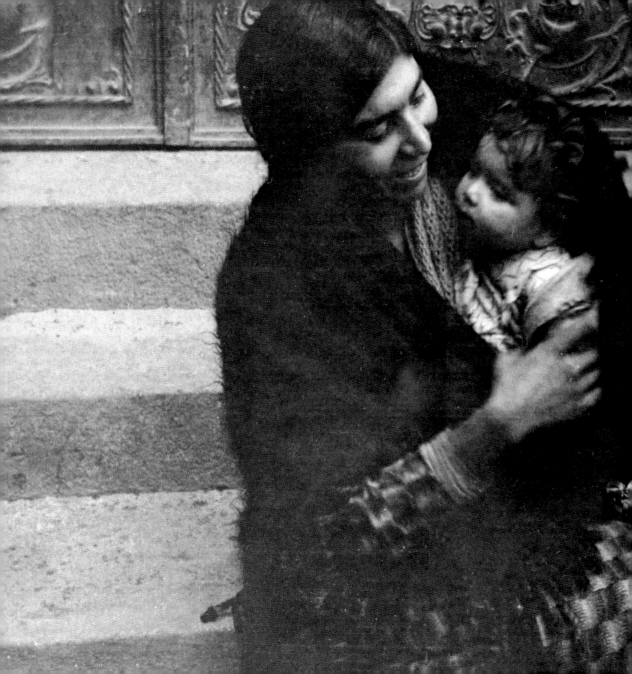

A mother and her child sit on the steps of a church in Madrid after a bombing raid. Taken on a Leica camera, Elkan described this as her best photograph. During her time in Madrid, she observed that many churches had been burned down, but most buildings were unscathed, and many civilians sought safety in the caves around the city.

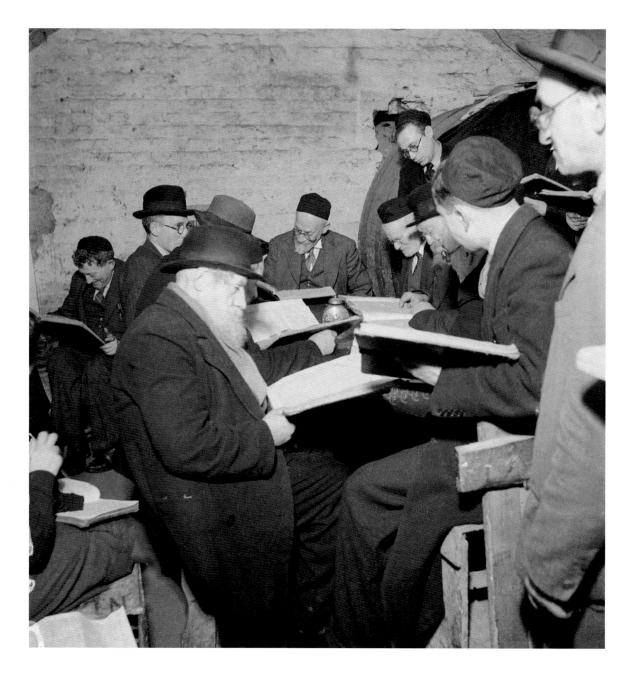

The Blitz was a sustained aerial bombing attack on Britain by the German Air Force. From 7 September 1940, London was bombed for 57 consecutive nights and again from mid-November, but the Luftwaffe also had far reaching targets across the country. Orthodox Jewish men studying the Talmud are photographed taking shelter in an East End wine merchant's cellar, London, November 1940.

In some air raid shelters men and women were required to segregate. This group of women occupy themselves by reading and knitting in an East End shelter, Christ Church, Spitalfields, London, November 1940.

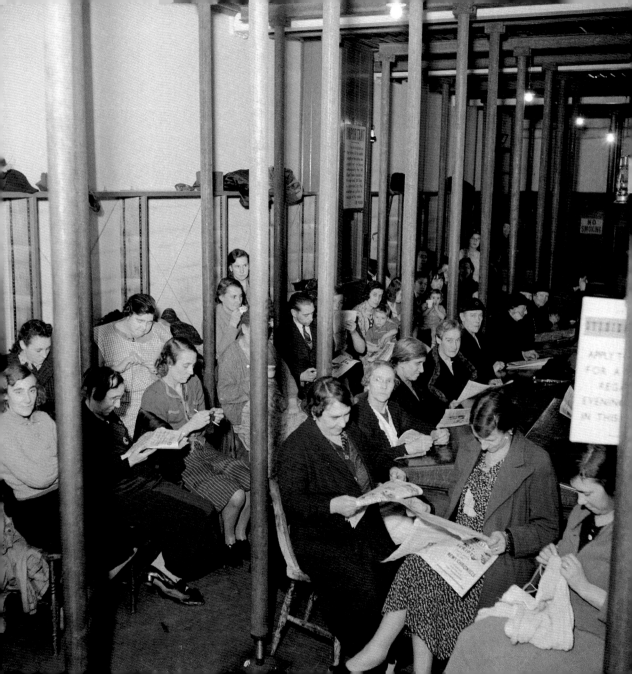

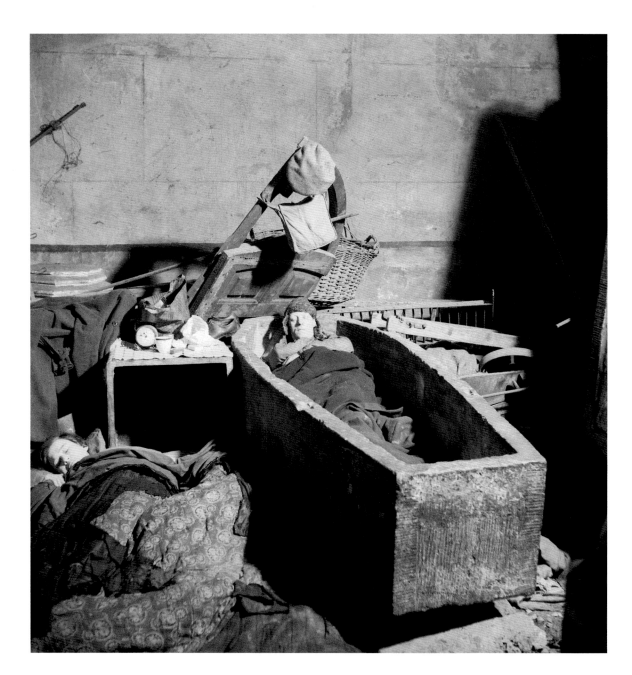

Despite the distribution of air raid shelters in 1938, the government encouraged people without sufficient space for their own to use communal shelters. These were often repurposed spaces and home comforts were limited or improvised. This man is photographed sleeping in a stone sarcophagus in Christ Church, Spitalfields, London, November 1940.

Londoners asleep on makeshift beds and chairs, Christ Church, Spitalfields, London, November 1940. A cropped version of this photograph, focused on the woman sleeping against the wall, appeared in *Lilliput* magazine in December 1942.

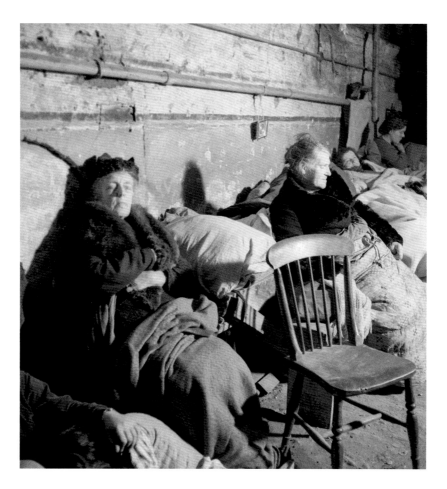

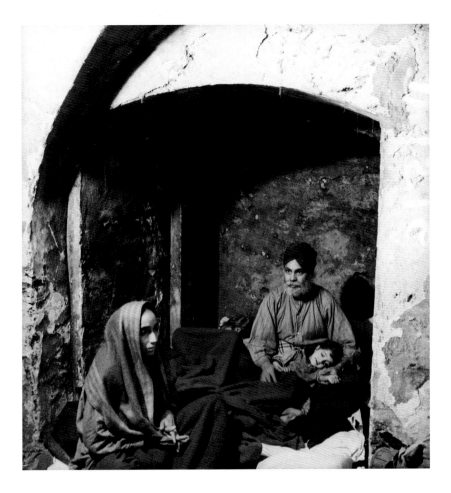

A Sikh family shelter in an alcove of
the crypt at Christ Church, Spitalfields,
London, November 1940.

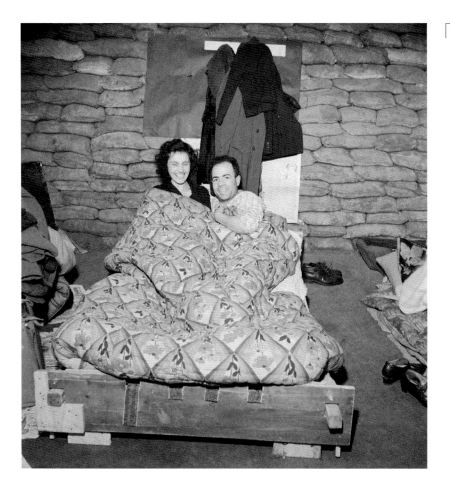

A man and woman wrapped in a large floral quilt in front of a sandbagged wall grin for the camera in a basement shelter of a West End shop, London, November 1940.

Londoners sleep in the spaces between the shelves and stock in the basement of a bookshop, Bloomsbury, London, November 1940.

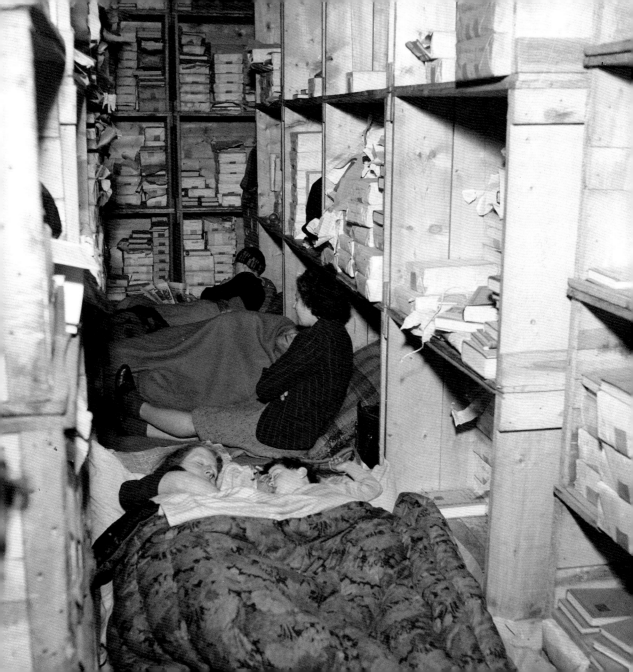

While initially reluctant for London Underground stations to be used as shelters, the government were later forced to overturn this decision. A group of men occupy their time by playing a game of draughts on the floor of Liverpool Street Underground Station, London, November 1940. One man appears to be wearing his slippers.

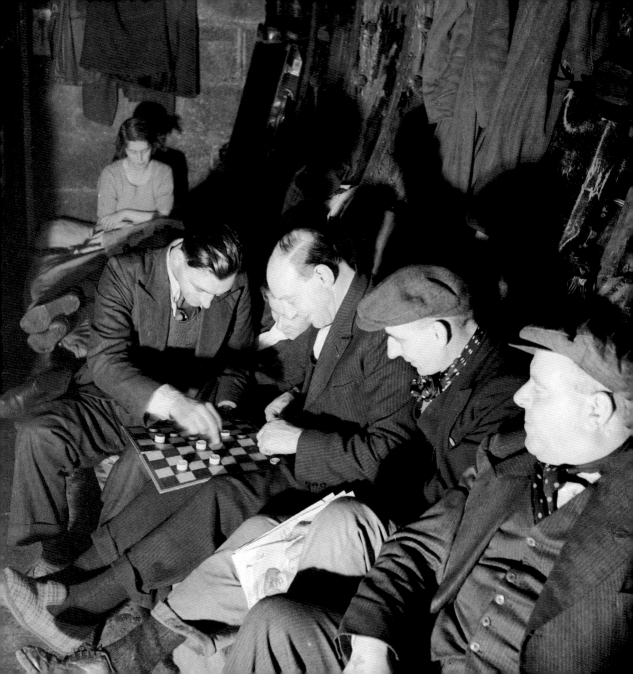

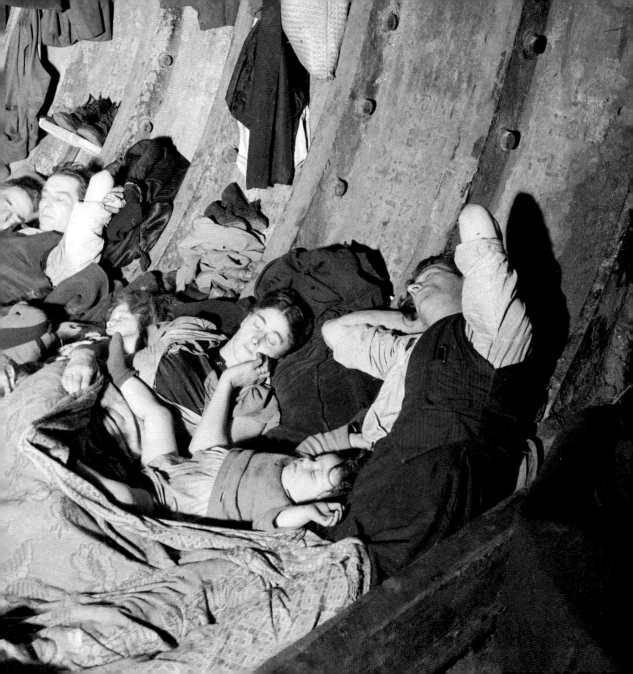

People sleeping against the arched walls of the tunnel at Liverpool Street Underground Station, London, November 1940. This photograph, published in *Lilliput* in December 1942, alongside Henry Moore's *Four Grey Sleepers* drawing, was described as 'typical of the thousands of Cockney families who made their home in the Underground during the blitz'.

People sleeping on the crowded platform of Elephant & Castle Underground Station, London, November 1940. Brandt photographed on a square medium format film but cropped this photograph ahead of publication, likely to maximise its impact and suit the style of the publication.

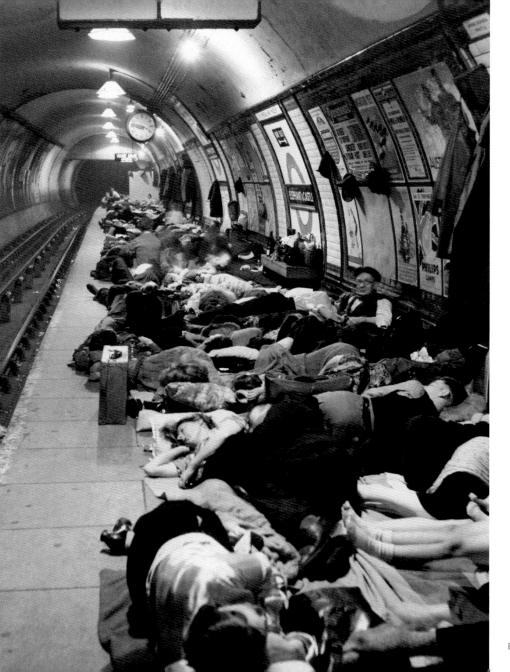

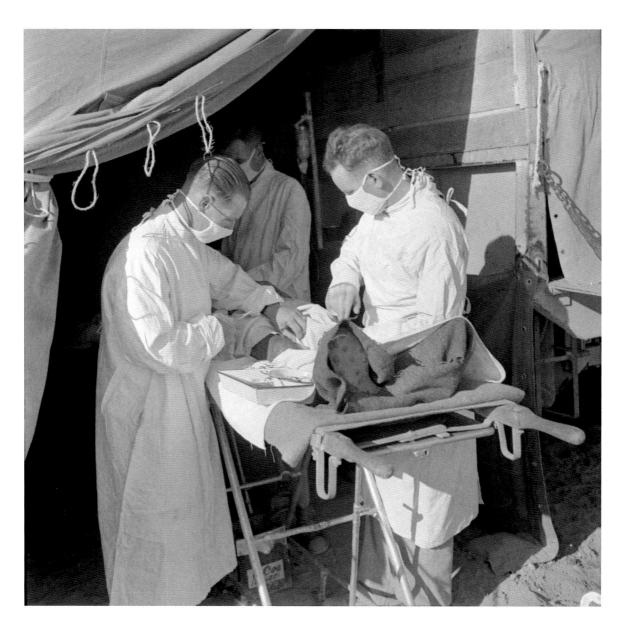

An emergency operation being performed at a forward dressing station, 5 November 1942. Taken in the Western Desert, in either Egypt or Libya, this is one of a sequence of photographs showing the Eighth Army's breakthrough of enemy lines. Sergeant Jimmy Mapham's first overseas deployment with the AFPU was to North Africa with No. 1 Army Film and Photo Section.

In addition to documenting the course of the war, photographers often captured more light-hearted moments, like the crew of this Bofors 40 mm anti-aircraft gun celebrating Christmas with some bully beef decorated with camelthorn, North Africa, 17 December 1942.

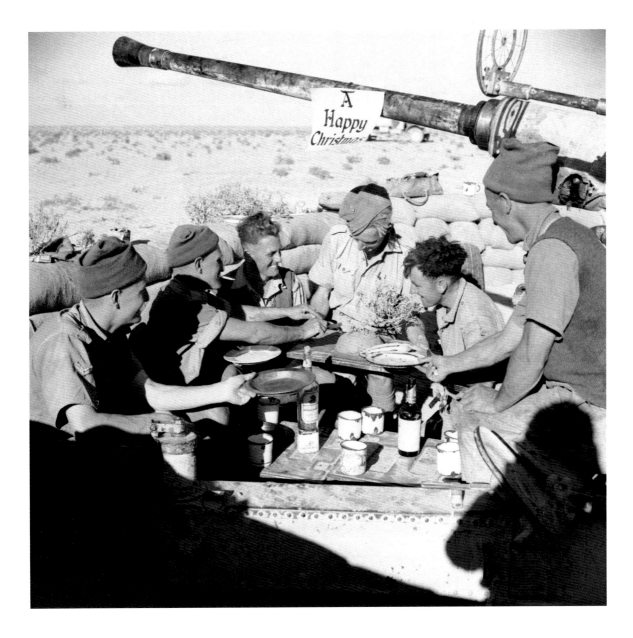

Paratroopers, Edward Bate and an Austrian counterpart, adjusting their parachute harnesses during one of the biggest British and US glider exercises ever held in England, 22 April 1944. This photograph was taken during the final phase of the exercise and 'demonstrated the great progress that had been made in the organisation and operation of airborne troops'.

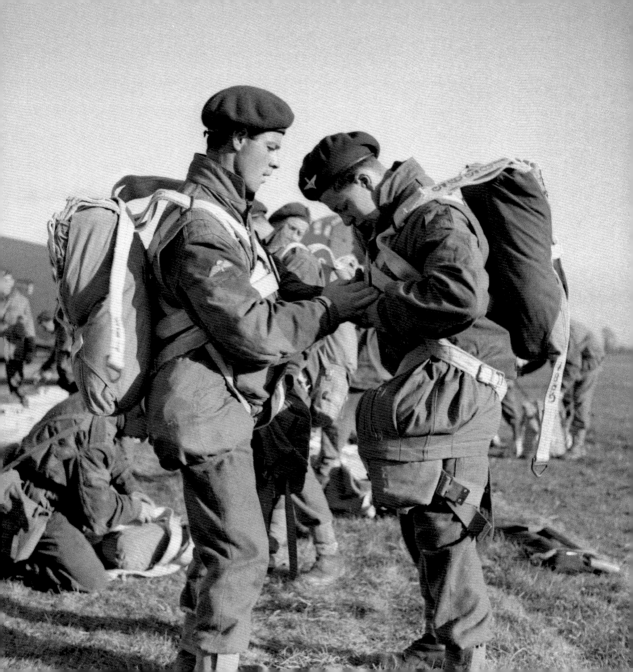

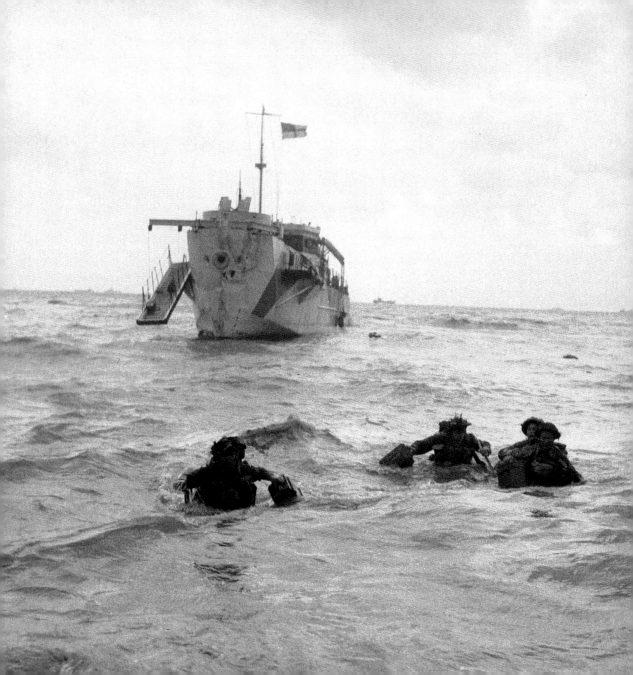

Commandos wading ashore from a landing craft (LCI(L)) on to Queen Sector, Sword Beach, Normandy, France, 6 June 1944. Mapham travelled across the English Channel and landed with the 13th/18th Royal Hussars (Queen Mary's Own), part of the 3rd Infantry Division, on D-Day.

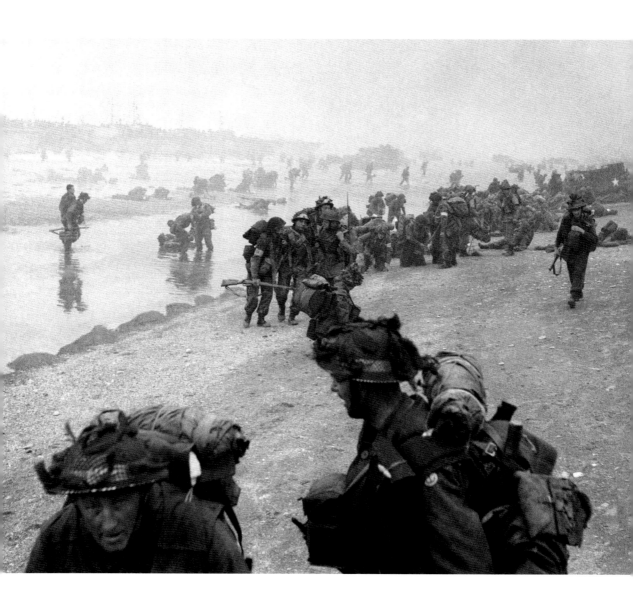

Troops of the 3rd Infantry Division on Queen
Sector, Sword Beach, Normandy, France,
c. 8.45am on D-Day, 6 June 1944. Mapham
was part of No. 5 Army Film and Photo
Section, AFPU, when he landed on D-Day.
Despite not being combat troops, these
men faced the same risks. Two members of
this unit were wounded on D-Day.

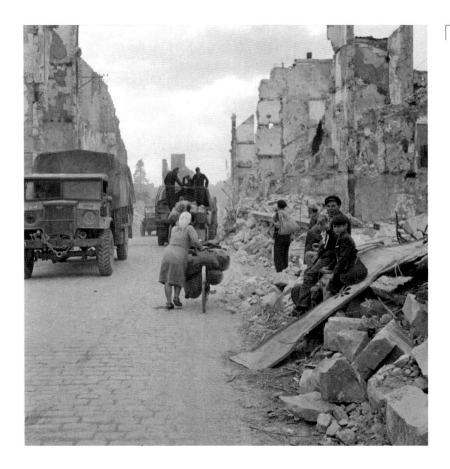

From D-Day, Mapham followed the Allied advance through Europe. In this photograph, displaced French civilians with bicycles and carts return to Falaise, France, in the aftermath of the Battle of the Falasie Pocket, 21 August 1944. Mapham captures the destructive nature of war on homes and the urban environment.

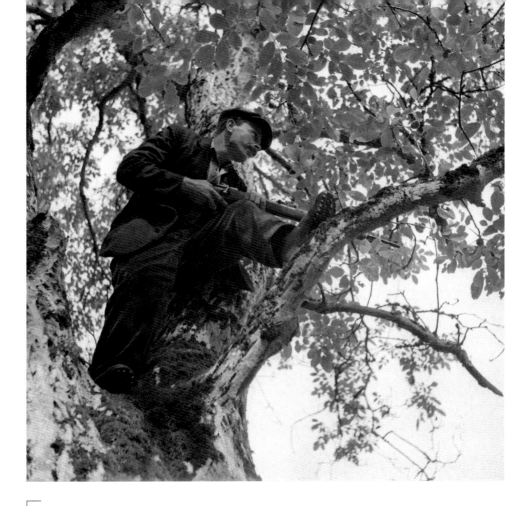

This photograph of a resistance fighter in a sniper position, hidden in a tree, forms part of a 'story in pictures of "True France"' taken in Beaumesnil, France, 30 August 1944, depicting 'the spirit of a gallant nation'. The villagers, who were part of the underground resistance, or French Forces of the Interior against the occupying German forces, not only fought to overthrow their occupiers but also aided the escape of 12 Allied airmen.

Mademoiselle Moreau, working with the Belgian resistance, bandages a minor wound for a British soldier in Antwerp, Belgium, 11 September 1944. After her imprisonment by German forces for underground activities, Moreau volunteered as a nurse on the frontline of Antwerp docks.

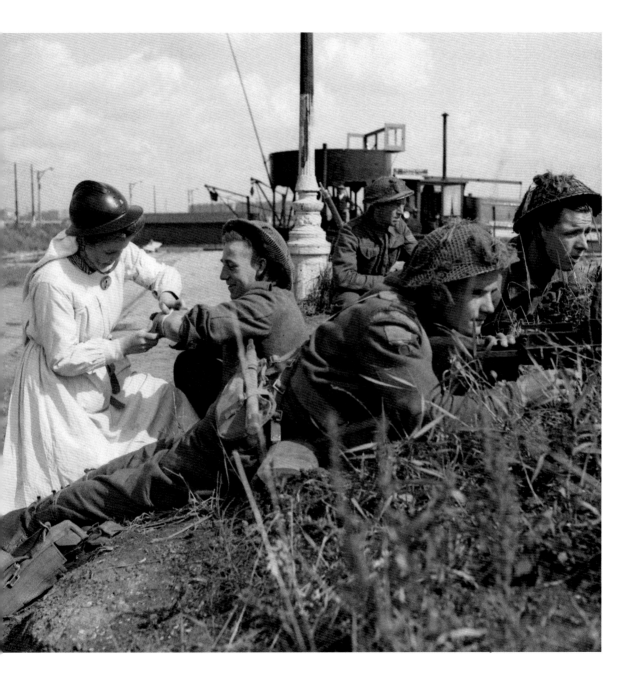

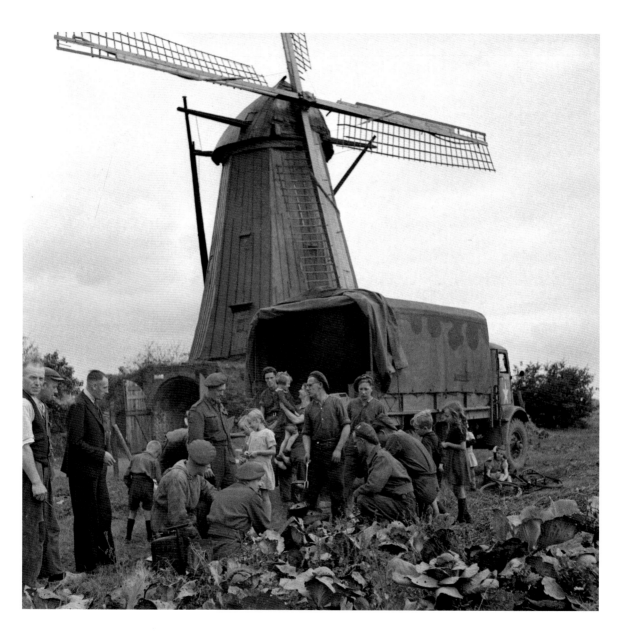

Taken in the Netherlands following the Battle of Arnhem, this photograph was originally described by Mapham as 'typical of the Dutch landscape is the Windmill and everywhere are to be found British Soldiers working near these windmills in Holland', 3 October 1944.

A Polish family registering at No. 17
Displaced Persons Assembly Centre in
Hamburg, at the Zoological Gardens,
Germany, 18 May 1945. The Displaced
Persons camp was built to house forced
labourers that worked at the Blohm & Voss
factory. The camp was taken over by the
British on 5 May 1945 and changed into
an arrivals centre for Displaced Persons.

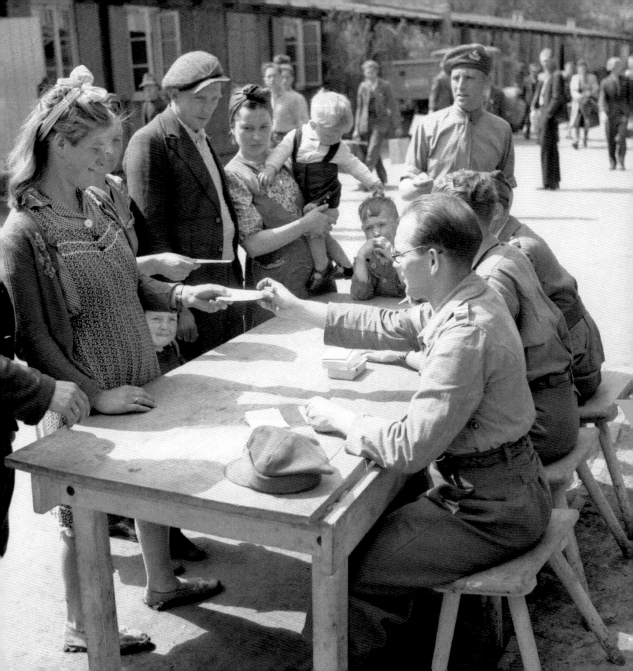

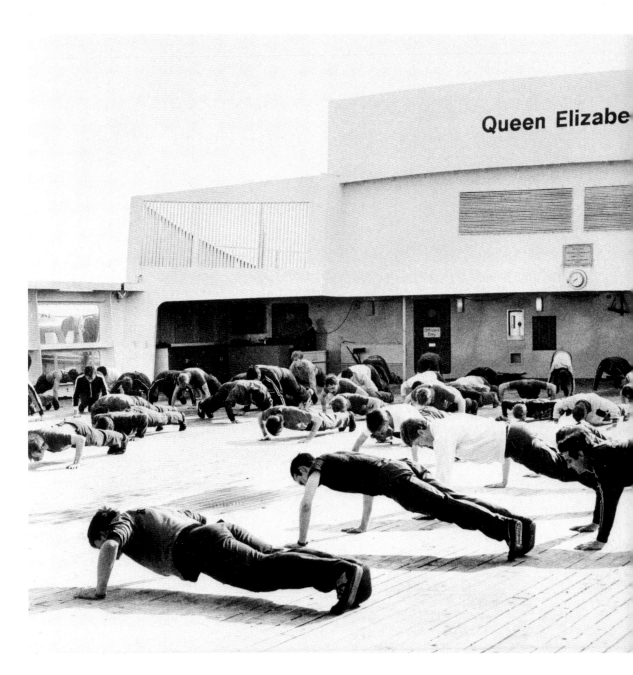

Paul RG Haley travelled on board RMS *Queen Elizabeth 2* (*QE2*) from Southampton on 12 April 1982 to Grytviken, South Georgia, before cross-decking onto the SS *Canberra* and landing at San Carlos, East Falkland. As well as photographing the preparations of the troops on board, Haley spent time preparing for situations he might encounter, such as practising changing rolls of film in the dark.

A helicopter lands while naval personnel stand on duty for deck training on board *QE2*. Haley regularly photographed helicopter activity, having been given the run of the ship and attending a safety briefing. The Falklands Conflict, codenamed Operation Corporate, was the first simultaneous deployment of all branches of the British armed forces since the Second World War.

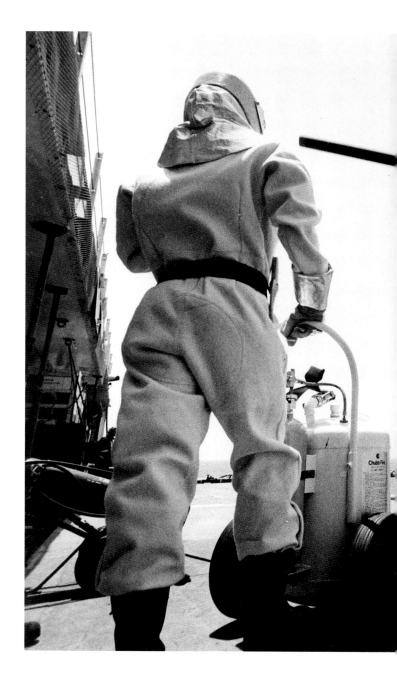

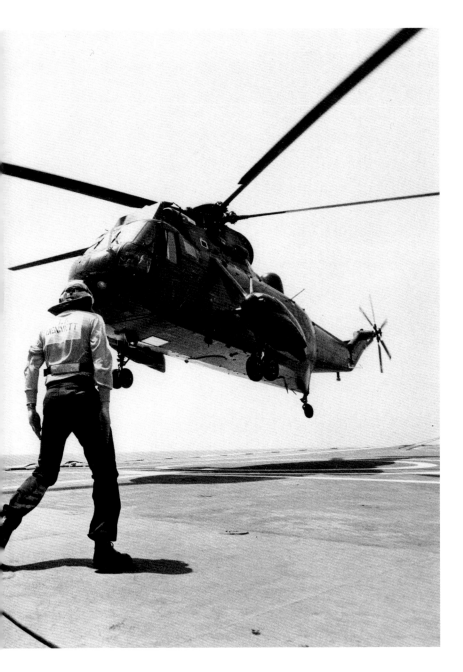

Haley landed with the 5th Infantry Brigade on Blue Beach, San Carlos, East Falkland, 1 June 1982, in the aftermath of the Battle of Goose Green. After disembarking from the Landing Craft (Utility) Foxtrot Four and walking up the jetty, Haley turned back to photograph the troops.

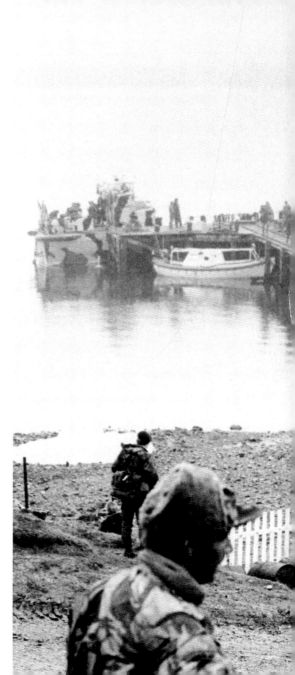

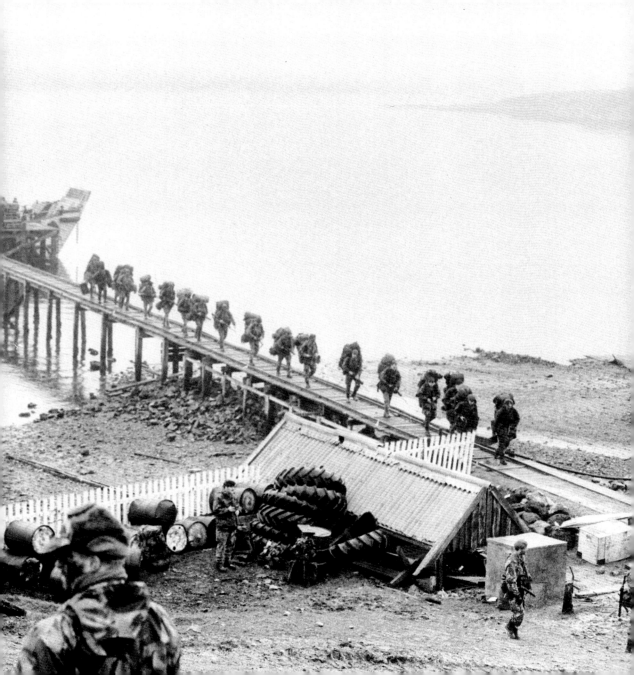

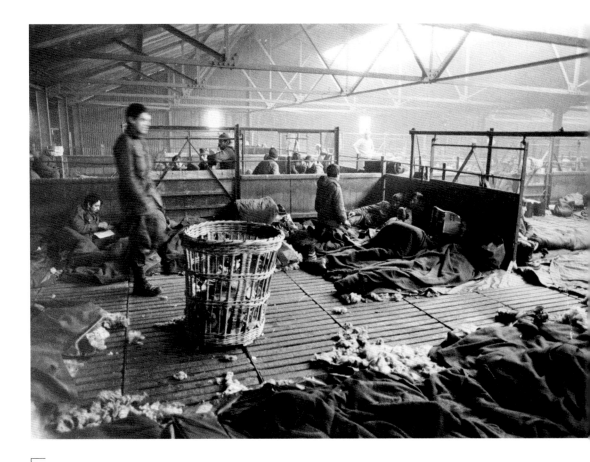

An interior view of a sheep shearing shed at Goose Green, East Falkland, used as a temporary holding area for Argentinian prisoner(s) of war. Haley approached the shed with caution, asking permission before he entered, as there was a mixed mood among the prisoners being guarded by the 2nd Battalion, Parachute Regiment.

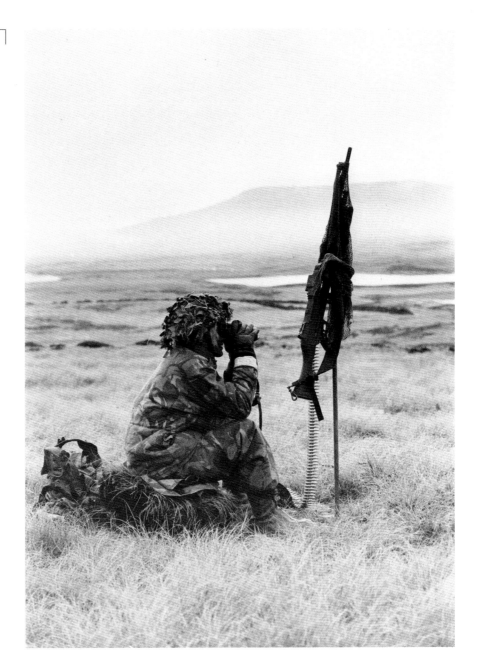

A soldier of the 1st Battalion, 7th Duke of Edinburgh's Own Gurkha Rifles, with a 7.62mm general-purpose machine gun (GPMG) on an anti-aircraft mounting at Darwin, East Falkland.

View of Fitzroy with RFA *Sir Galahad* burning offshore, 9 June 1982. The *Sir Galahad* was bombed by Argentinian forces on 8 June 1982 while transporting troops to Bluff Cove, East Falkland, during the British advance towards Port Stanley, the capital of the Falkland Islands.

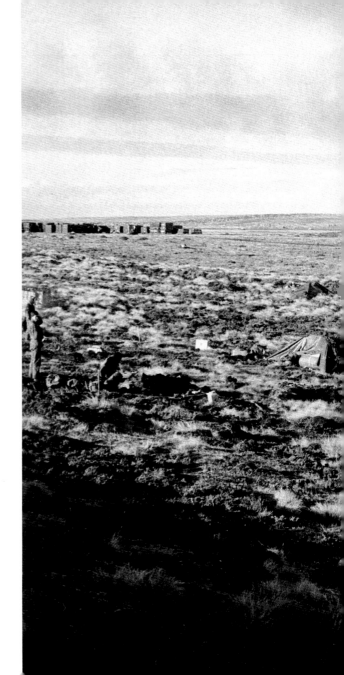

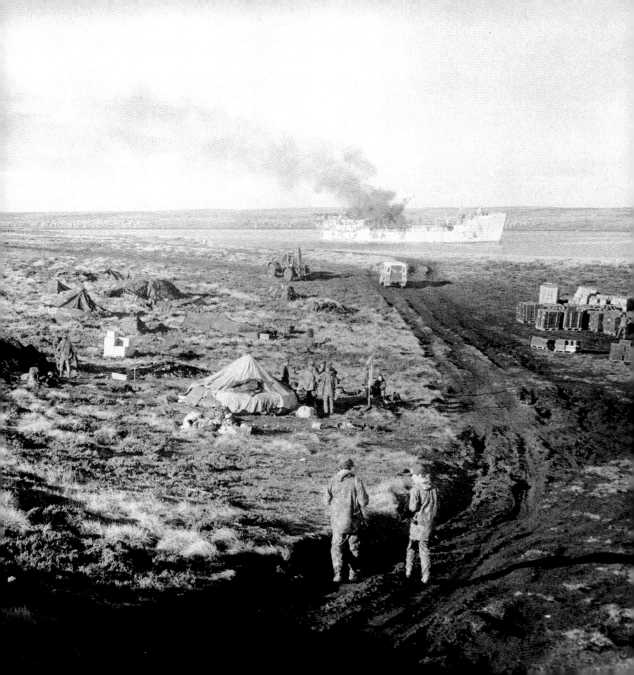

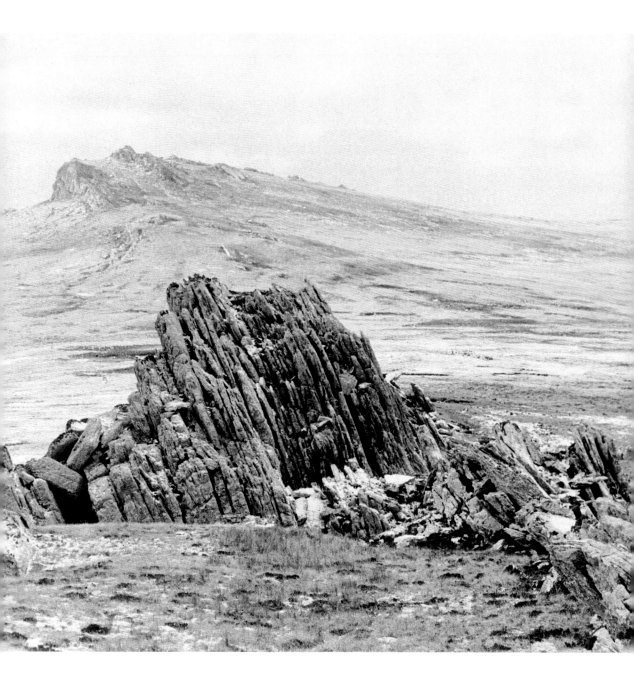

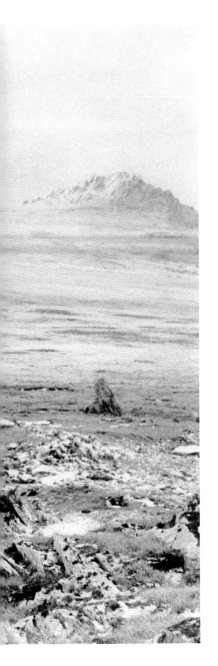

A view of the mountainous terrain on the Falkland Islands, taken from the east end of Goat Ridge. On the left is Mount Tumbledown and on the right is Mount William.

A signaller using his radio at first light, photographed by Haley en route to Mount Tumbledown, 14 June 1982. Haley reached the top of Tumbledown with 7 Platoon, G Company, 2nd Battalion, Scots Guards. Later that morning the message 'check fire' came over the radio meaning the Argentinian forces had surrendered.

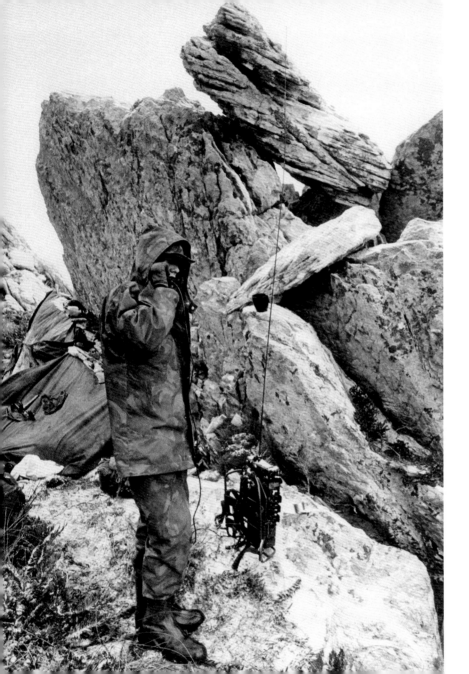

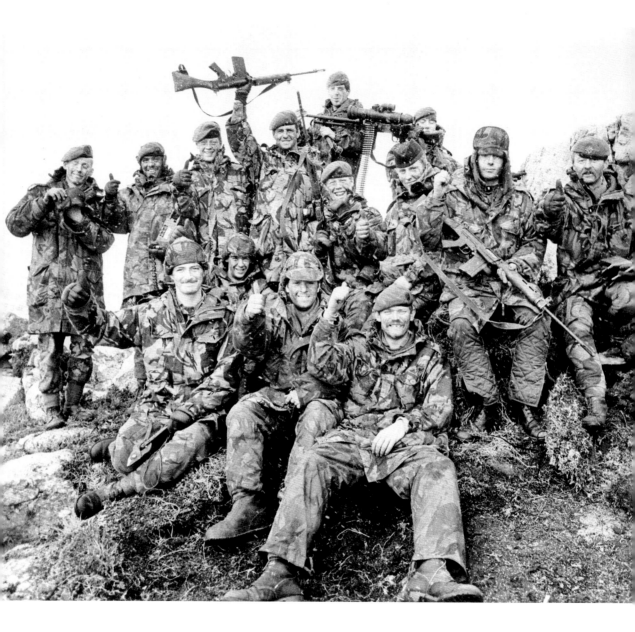

7 Platoon, G Company, 2nd Battalion, Scots Guards, on Mount Tumbledown celebrate the news of the Argentinian surrender at dawn on 14 June 1982. Described by Haley as one of the photographs he is most proud of, in part due to the difficulty organising the troops. From Tumbledown, Haley went to Port Stanley to photograph the results of the Argentinian occupation and surrender.

A picture of the Madonna taped to the butt of a surrendered Argentinian rifle at Port Stanley. Haley positioned the rifle on the top of the pile to compose the photograph. Haley remarked 'Iconic images don't just happen by themselves!'

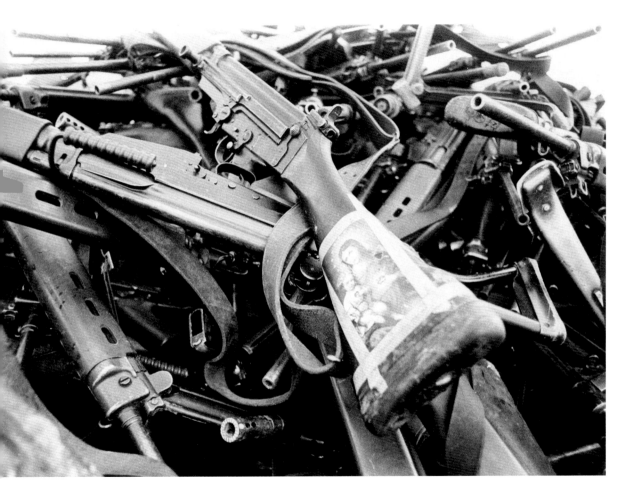

Image List

HU 672 (detail), Q 7950, Q 7955, Q 7967, Q 7969, Q 7976, Q 8003, Q 8028, Q 8046, Q 8049, Q 8117, HU 71502 © The rights holder, HU 71509 © The rights holder, HU 71546 © The rights holder, HU 71553 © The rights holder, HU 71578 © The rights holder, HU 71600 © The rights holder, HU 71642 © The rights holder, HU 71646 © The rights holder, HU 71665 © The rights holder, HU 71499 © The rights holder, D 1509, D 1510, D 1511, D 1513, D 1516, D 1521, D 1525, D 1581, D 1575, HU 672, E 18977, E 20242, H 37730, B 5092, B 5114, B 9577, B 9838, BU 833, B 10587, BU 6634, FKD 219 © Crown/ Soldier Magazine, FKD 230 © Crown/Soldier Magazine, FKD 275 © Crown/Soldier Magazine, FKD 246 © Crown/Soldier Magazine, FKD 249 © Crown/Soldier Magazine, FKD 327 © Crown/Soldier Magazine, FKD 316 © Crown/Soldier Magazine, FKD 325 © Crown/Soldier Magazine, FKD 314 © Crown/Soldier Magazine, FKD 298 © Crown/Soldier Magazine.

Source List

© IWM unless otherwise stated

'Letter from Dame Maud McCarthy to Lady Norman',
 26 February 1919 (EN1/3/VIS/004)
'Letter from Olive Edis to Lady Norman', 7 April 1919
 (EN1/3/VIS/004)
Interview with Vera Elkan, 1996, IWM Sound Archive
 (Reel 4, 16900)
Interview with Paul RG Haley, RM Military History, accessed July
 2023 <https://www.youtube.com/watch?v=6TrV4osBapw>
 © RM Military History
'The Record of a Journey to Photograph the British Women's
 Serviced Overseas Begun on Sunday March 2nd 1919',

Private Papers of Miss O Edis (Documents.140)
© The rights holder
Interview with Vera Elkan, 1996, IWM Sound Archive
(Reel 4, 16900)
Lilliput, Vol. 11, No. 6, Issue 66, (December 1942), p.477.
© The rights holder
Mapham, James, Dope Sheet B 10587-B 10588, 3 October 1944
(OPA2/04/01/02/004)
Interview with Paul RG Haley, 2022, IWM Sound Archive
(Reel 11, 37195)

About the Author

Helen Mavin is Head of Photographs at IWM and has worked with the IWM Photograph Archive for over a decade. She has contributed to IWM exhibitions including Robert Capa: D-Day in 35mm, Wim Wenders: Photographing Ground Zero and The Blavatnik Art, Film and Photography Galleries.

Acknowledgements

I would like to thank Lara Bateman (Publishing Officer), Alan Wakefield (Head of First World War and Early 20th Century), Toby Haggith (Senior Curator, Second World War and Mid-20th Century), Paris Agar (Head of Cold War and Late 20th Century) and Bryn Hammond (Principal Curator, Collections) for their help with this book. Thanks also to IWM Photograph curators past and present whose collective knowledge and care for the collection has shaped this publication.